Ancient Greek pottery

Michael Vickers

Ashmolean Museum Oxford
1999

Text and illustrations © The University of Oxford:
Ashmolean Museum, Oxford 1999
ISBN 1 85444 115 9 (papercased)
ISBN 1 85444 114 0 (paperback)

Titles in this series include:
Ruskin's drawings
Worcester porcelain
Italian maiolica
Drawings by Michelangelo and Raphael
Oxford and the Pre-Raphaelites
Islamic ceramics
Indian paintings from Oxford collections
Camille Pissarro and his family
Eighteenth-century French porcelain
Miniatures
Samuel Palmer
Twentieth-century paintings

British Library Cataloguing in Publication Data
A catalogue record for this book is available from the
British Library

Cover illustration: Volute-crater, no. 35

Designed and typeset in Versailles by Roy Cole
Printed and bound in Singapore by Craft Print Pte Ltd

Preface

The Ashmolean has a large and important collection of Greek pottery, and especially of painted pottery. The scenes give us an unparalleled insight into the everyday life and religious beliefs of the ancient Greeks. The shapes (which are usually based on work in metal) give an idea of the lost art of the Greek silversmith. Many pieces are illustrated for the first time in colour. The study of Greek ceramics has entered a new and exciting phase: questions of attribution are taking second place to a consideration of the role of pottery in antiquity.

One of the foremost scholars in earlier times in the field of Greek pottery studies was the late Sir John Beazley (1885–1970). Dr Dietrich von Bothmer was one of his closest students, and thanks to his generosity and that of his wife Joyce von Bothmer, the Museum has recently been able to construct the Bothmer Gallery, and to refurbish the Beazley Gallery, where the pots illustrated here may be seen.

Michael Vickers
Reader in Archaeology

Introduction

Greek pottery has survived in great quantity, and the Ashmolean has a large collection. By far the greater part was made at Athens (although much was found elsewhere, having been exported in antiquity). Athenian fine pottery was wheel-made, and fired at between 800 and 950 degrees Centigrade. The characteristic black-gloss surface of many pieces was achieved by means of the addition of an agent (a 'peptising agent') to a solution of the clay from which the pot was made and which fired black when water vapour was added to the kiln under 'reducing conditions' on a second firing. The ruddy parts of the pot were also slipped. Much artistry went into the decoration of some pots, and much ingenuity has been spent on attributing pots to individual hands. Names were devised to fit the supposed artistic personalities, careers invented, and a whole folklore created, but recent research has shown that the shape and decoration of pots were largely dependent on the norms of other media, with designs, even 'signatures', coming through from the *graphides* that acknowledged artists made for silversmiths. Attribution of pots is an activity whose scholarly value is slight, and little attention will be paid to it here.

Most complete vessels come from graves, which immediately raises questions about the status of pottery in antiquity. Since many pieces were found in rich burial contexts in Etruria, and the Etruscans were famous in antiquity for their luxurious way of life, it used to be thought that Greek pots (or 'vases') were the physical evidence of that luxury. More recently, it has been noted that in life rich Etruscans used silver and gold plate, and that

ceramic grave goods served as surrogates, or sub-
stitutes, for precious materials which would
otherwise have presented temptations to grave-
robbers. Pottery was a medium that enabled high
quality, but low cost, versions of vessels of gold,
silver, bronze or ivory to be made.

'Skeuomorphism', the principle according to
which objects made in one medium might be evoked
in another, usually cheaper, material, is a term
widely used to reconstruct gaps in the archaeologi-
cal record. While some traditional shapes may have
owed their original forms to work in other low-cost
media, such as wood, leather or gourds, in their
developed state they frequently evoke the character-
istics of metalwork. The impact of the smith on the
ceramic record has been described as a series of
'metallurgical shocks', and accounts for such details
as 'the reproduction of shapes for which clay is ill-
fitted, and of details, such as rivets, which are func-
tionless' (cf. Fig. 1), as well as figural and relief
decoration of a kind that can occasionally be found
on extant metalwork.

It has been estimated that the Athenian silver
mines at Laurium produced twenty tonnes of silver
per annum. It was mostly made up into vessels and
coinage (silver vessels serving, in effect, as large de-
nomination bank notes: gold and silver vessels were
regularly made up into round figures in prevailing
monetary units. A character in Aristophanes' *Baby-
lonians* of 426 BC says: 'I owe a debt of 200 drach-
mas. How can I pay it?' His companion replies:
'Here, take this silver cup and pay for it with that').
Very little Greek silverware has survived, and most

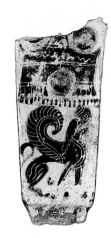

Fig. 1
AN 1951.360. Boeotian
pottery tripod pyxis
fragment. Gift of Dr
Dietrich von Bothmer

Fig. 2

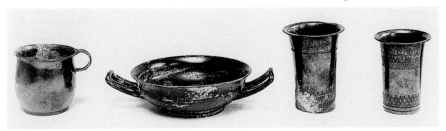

of it is plain. The little we have comes for the most part from graves in Scythia and Thrace (Ukraine and Bulgaria), as well as in Macedonia. An old photograph of vessels from a grave at Dalboki (Fig. 2; Ashmolean AN 1948.104, 1948.105, 1948.102, and 1948.103) shows a mug and two silver beakers before they were cleaned, together with an Athenian pottery drinking cup; the shiny surface of the extremely pure silver (respectively 98%, 98.5% and 99.4%: analysed by Z. Stos of the Oxford Research Laboratory for Archaeology and History of Art, using energy dispersive X-ray fluorescence) is remarkably similar to that of the pottery cup. Surviving decorated wares are much rarer, but again they have their ceramic analogues. A silver drinking vessel from Duvanli, and now in Plovdiv, shows how gold-figure decoration might lie behind red-figure ceramics. The satyr and maenad stand on a gold groundline (Fig. 3), just as the boy stands on the 'reserved' groundline of an analogous pot (Fig. 4). The Duvanli kantharos was made to weigh 250 drachmas (or £450 at the time of writing).

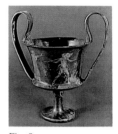

Fig. 3

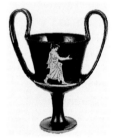

Fig. 4

Pottery by comparison cost very little (see No. 36). The images of aristocratic life: drinking at the symposium, exercising in the gymnasium, hunting; the mythological scenes, should be viewed as having been based on designs for vessels decorated in silver-on-bronze ('black-figure'), or gold-on-silver ('red-figure') made for an elite market. Greek potters were highly skilled at evoking the surface effects of more expensive materials, even of ivory (which lies behind much 'white-ground' pottery). Paradoxically, it was often the effect of corrosion products that were reproduced. Today, however, it is the green patina on bronze that is prized, while silver is usually brightly polished. In antiquity the patina that forms naturally on gold and silver seems to have been tolerated, judging by surviving ceramic 'chromostats': the ruddiness of accretions on gold, and the duskiness of tarnish on silver seem to have been evoked by contemporary potters. The phenomenon can more easily be explained if their precious

6

metal prototypes were indeed valued by weight, for it would have been possible to see 'negative interest' coming off on a duster if silver was kept brightly polished.

There is much that we can learn from Greek pots even though some of them may no longer have been decorated by the greatest artists of the day. Greek graphic arts lie at the fountain-head of Western European art. The large-scale murals have disappeared that formerly adorned such monuments as the Lesche of the Cnidians at Delphi or the Stoa Poikile at Athens – buildings which enjoyed as much renown in antiquity as do the Arena or Sistine Chapels today. We can gain some idea, albeit a slight one, of the technique and content of these lost masterpieces by studying paintings on pots. We can see, for instance, how Greek craftsmen, working on whatever scale (and in various media including painting, metalwork, and tapestry design), successfully achieved in the middle of the first millennium BC the realistic representation of the human body in motion, with accurately rendered foreshortenings. And some of the mythological scenes on pots clearly have parallels in lost paintings. This, however, is scarcely surprising in that important artists, in both antiquity and the Renaissance, used to design all manner of artefacts on both large and small scale as required by their patrons. The painter Parrhasius, who flourished in the second half of the fifth century BC, made designs (called *graphides*) on boards and parchment which were still being used by craftsmen in the Roman period.

At a more mundane level, finds of pottery can be very helpful in archaeological excavations both for comparative dating and also as a guide to the trading connections of a given site. While the precise chronology of Geometric and archaic Greek artefacts is the subject of considerable scholarly debate (which is why dates here are given in the widest terms), the fact that similar classes of material occur at certain levels in different sites enables useful comparisons to be made. By the later fifth

century BC dating is less controversial, and it is possible for example to date the rich Dalboki tomb group from Bulgaria (Fig. 5), which includes a gold breast plate and silver drinking vessels, to the last quarter of the fifth century BC on the evidence provided by the Athenian black-gloss pottery.

Greek pottery found on sites around the Mediterranean has often been used to establish possible ancient trading links, but it is a less sure guide than might at first appear. It is one thing to note the existence at Al Mina in Syria of, say, Euboean and Cycladic imitations of pots made in Corinth (or more accurately perhaps, of metal vessels of a kind reflected in the Corinthian ceramic record); but another thing altogether to be sure that Euboeans were in the vanguard of Greek trading activity in Syria. Such an analysis, which tends to overlook the ubiquitous role of the Phoenicians in the carrying-trade of the ancient Mediterranean, need not detain us.

No one would suggest that there was a pre-existing metal vessel for every decorated pot; simply

Fig. 5

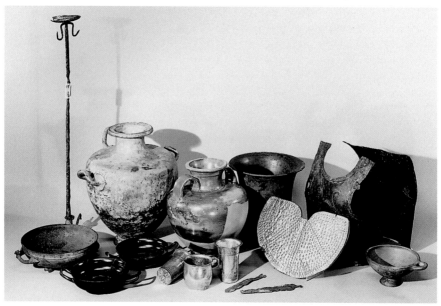

8

that most fine pottery in archaic and classical times was made according to norms created in other media. Silversmiths' patterns set the standards; pot-painters, however, did not slavishly restrict themselves to an aristocratic representational repertoire, but occasionally showed men – and women – at work: potters in their workshop, a shoemaker, an armourer, a furniture-carrier, women winding wool. This is an area in which the Ashmolean is peculiarly rich, reflecting the fact that the Oxford collection was largely formed when the Arts and Crafts movement was at its height. Greek pot-paintings in general, however, give us a wealth of information concerning contemporary social life and religious beliefs and practices, and they allow us to see in a way only matched in the West in the art of seventeenth-century Holland or nineteenth-century France, how people actually lived.

Greek pots have been collected and studied ever since the fifteenth century, and there were many misconceptions from the start, notably that the mainly Attic pots found in Etruscan tombs were of Etruscan manufacture – a belief that led Josiah Wedgwood to call his Staffordshire factory, where he produced pottery bearing classical decoration, 'Etruria'. This particular error was only dispelled during the course of the eighteenth century – and there is still an Etruria near Stoke-on-Trent. It was once the mark of enlightened patronage to collect what used to be called 'Greek vases', and the roll-call of donors and former owners of the Greek pots in the Ashmolean is an illustrious one. It includes such luminaries as Sir Arthur Evans, C. D. E. Fortnum, Capt. E. G. Spencer-Churchill, Sir John and Lady Beazley, James Bomford, Dietrich von Bothmer and Richard Hattatt. Nowadays, however, the collection of Greek and Roman antiquities is widely thought to occupy a position on the moral spectrum somewhere between smoking and paedophilia. It has earned this reputation because the material is frequently illicitly excavated, illegally exported and sleazily sold. Tomb-robbing has become a fine art in

some parts of the world, and there are still scholars willing to dignify the fruits of such labours with attributions in order to enhance their value on the art market. In doing so, they only serve to impoverish a proper understanding of the past.

Archaeologists have given names to the various shapes of Greek pottery vessels; for several there is in fact little or no ancient evidence that the names applied to them are accurate, but they are convenient. The functions of most vessels (or at least of their metal prototypes) are simple: the amphora, *stamnos* and *pelike* would have been used for holding oil or wine; the *hydria* was for fetching water; craters of various forms were used for mixing wine with water and the ensuing mixture would be poured from an *oinochoe* or an *olpe* into a cup, a *skyphos*, a *rhyton* or a *kantharos* from which it would be drunk. Other shapes had other uses: the *pyxis* was a trinket or cosmetic box, the *alabastron* and *aryballos* were made to contain perfumes, and the *lekythos* was regularly employed for making offerings of oil at the grave. Many of these shapes enjoyed a renewed vogue in subsequent periods, notably in the eighteenth century, when they were used as models by contemporary silversmiths and porcelain manufacturers.

Place names mentioned
in the text

Acknowledgements

The photographs are the work of Nick Pollard and
David Gowers of the Ashmolean's photographic
studio. Many thanks are due to Julie Clements and
Mira Hofmann for help with photography and the
preparation of the text. Gareth Harris advised on
questions relating to silversmithing. The drawings
on page 79 are derived from those originally
executed by Lindsley F. Hall of the Metropolitan
Museum, New York.

1 Pitcher
Athens, Late Geometric IIa, 8th–7th century BC

This high-necked pitcher is decorated with geometric designs of the kind from which the Early Iron Age in Greece – the Geometric period – derives its name. There are bands of cross-hatched triangles, of dotted lozenges, dots and zig-zag lines but the main decorative field on the neck consists of a meander band – the 'Greek key' pattern – amid vertical bands of decoration and simple rosettes. The motifs may derive from textile working.

AN 1965.142. Formerly Spencer-Churchill collection. H: 37.7 cm

Lit.: Spencer-Churchill 9, No. 45, pl. 4; GV No. 1

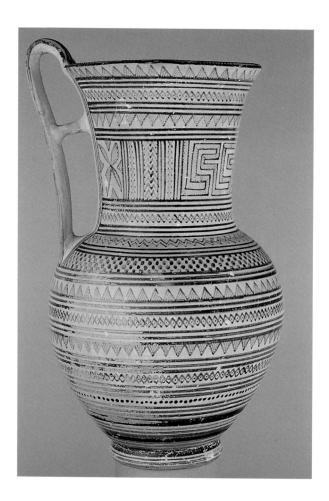

2 Amphora
Athens, Late Geometric IIb, 8th–7th century BC

The principal decoration is a *prothesis* scene – a funeral with the deceased shown lying on a bier attended by mourners. Geometric art stands at the beginning of the Greek pictorial tradition and though apparently childish, it possesses an underlying logic. Each part of the body is shown with its most characteristic viewpoint: heads in profile, chests frontally, and legs from the side. Women wear skirts and men have little swords. The deceased lies beneath the pall – which is why it is in the air above him. Between the figures are filling ornaments: stars, lozenges and zig-zags; features which indicate the origin of the design in textile work (filling ornament has been well explained as the result of 'a desire to strengthen the stuff by making the warp and woof interlace as frequently as possible, instead of being stretched across large expanses of one colour' [E.A. Gardner]).

AN 1916.55. Gift of E.P. Warren. H: 67.5 cm

Lit.: J.N. Coldstream, *Greek Geometric Pottery* (1968) 55, No. 11; G. Ahlberg, *Prothesis and Ekphora in Greek Geometric Art* (1971) fig. 33 a–e; *GV* No. 2; *Artful Crafts* 112

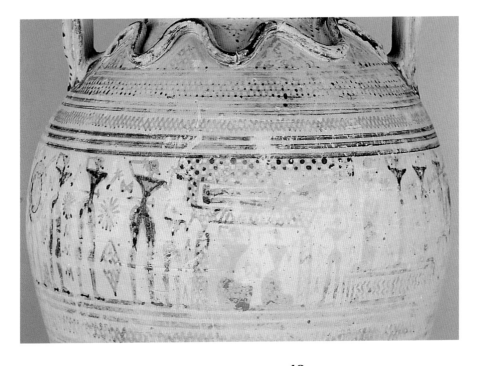

3 Amphora
Athens, Early Proto-Attic, 7th century BC

The designs on Geometric pots gradually became softer and more curvilinear under the influence of imports from the Near East, among which luxury metalwork and textiles will have been prominent. Thus the bands of subsidiary decoration on the neck of this vessel consist of curves and loops instead of the earlier zig-zags and triangles, and the bands elsewhere have become summary. There are rows of animals at the base of the neck and on the shoulder: horses in the one case, and deer in the other. The principal decorative areas are on the belly and neck. The former has a procession of chariots derived from the Geometric repertoire, but the latter has the most up-to-date feature: rows of elegant, organically drawn 'runners' whose form and proportions look forward to those to be found painted on Athenian black-figure pots of the sixth and fifth centuries. Note the plastic snakes on the handles and the struts which fill up most of the space between the handle and the neck.

AN 1935.19. H: 52.2 cm

Lit.: C. King, *American Journal of Archaeology* 80 (1976) 78–80, pl.13, figs. 1–2; *GV* No. 3

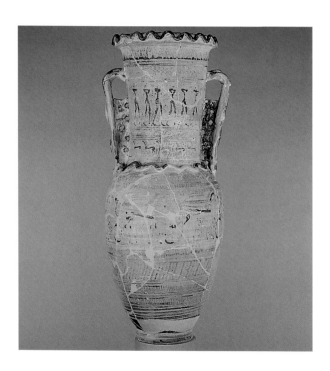

4 Olpe
Corinth, 7th–6th century BC

The body is divided into bands, the uppermost decora-
ted with a frieze of orientalising animals: a stag between
lions with carefully painted rosettes in the field, and the
next with compass-drawn scales. Below this is another
frieze of animals: a doe, two lions, a goat and two lions,
and beneath, red and yellow lines on brown. Finally,
rays above base. The details of the animals and the
scales are incised and there is also some added red and
yellow. The presence of rosette filling ornament indi-
cates a textile origin for the main designs. There is a
triple handle with rotellae at the rim: a feature originally
devised for metal vessels.

AN 1879.100 (V. 177).
Found at Camirus,
Rhodes. J. Henderson
bequest. H: 27.5 cm

Lit.: *CVA* 2, IIIc, pls.5.13,
20; 6.9, 13; *GV* No. 7

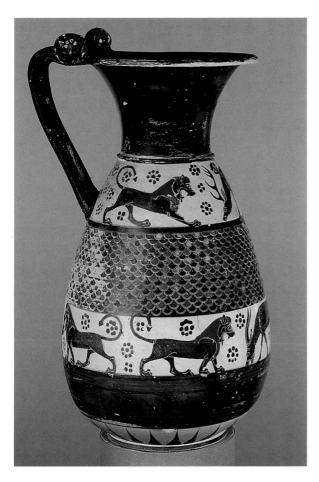

5 Oinochoe
East Greek, 7th–6th century BC

Paradoxically, the orientalising style was relatively late in gaining popularity in the East Greek world (western Asia Minor and its offshore islands), but when it did the most popular form of decoration on pots was the Wild Goat style. Here, most of the body of the pot is covered with a cream-coloured slip, over which are painted, on the shoulder, a grouching griffin between two browsing goats, and on the belly, four goats with a water-bird beneath the handle. These bands have a profusion of variegated filling ornament, some suspended from the upper edges, and some apparently growing from the lower; their presence indicates a textile source for the design. The neck has a cable pattern, and around the bottom is a pattern of lotus buds and flowers. The rotellae at the junction of handle and neck indicate the potter's dependence on a metal model for the shape.

AN 1966.1021. Gift of Sir John Beazley. H: 33 cm

Lit.: *CVA* 2, IId, pl. 2.1, 2; *Beazley Gifts* 33, No. 83, pl. 7; *GV* No. 8

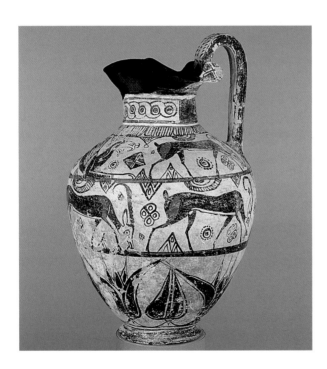

6 Plastic vases
East Greek, 7th–6th century BC

'Plastic' vases because they are made in a mould (Greek *plasso* – mould). *Left*: a perfume-pot in the shape of a sandalled foot. *Centre*: a perfume-pot in the shape of a warrior's head. It belongs to the Gorgoneion style, so-called after a Gorgon-head vase in Vienna. The helmet is of Ionian type with folding cheekpieces and a small palmette and spiral decoration over the forehead. The details of the face: eyebrows, eyelids, pupils and moustache are added in black, and the whites of the eyes in white. *Right*: a Gorgoneion style perfume-pot in the shape of a monkey. The pale red clay has a deep red slip over which are painted brown spots. Details of the eyes are done in black and white.

Left: AN 1954.12. Found at Taranto. H: 8 cm

Lit.: *GV* No. 9

Centre: AN 1879.137. Found at Camirus, Rhodes. J. Henderson bequest. H: 6.3 cm

Lit.: *CVA* 2, IId, pl. 8.1; *GV* No. 9

Right: AN 1879.186. Found at Camirus, Rhodes. J. Henderson bequest. H: 9.5 cm

Lit.: *CVA* 2, IId, pl. 8.5–6; *GV* No. 9

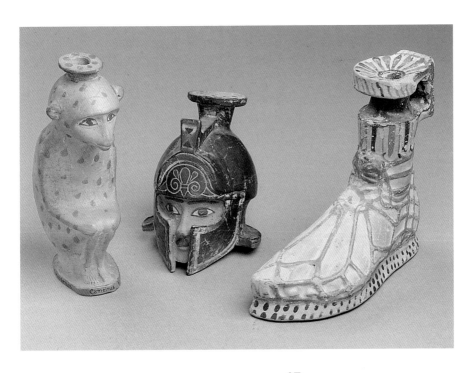

7 Cup
Corinth, 6th century BC

Padded dancers, or 'komasts', some with artificial phalloi appear in this riotous scene. Some hold drinking horns, and one a jug. The precise significance of padded dancers is uncertain. Their origins may lie in a rustic fertility ritual, but their frequent appearance on Corinthian pots (though rarely as unruly as this) suggests that they may have become conventional decorative ornaments. On the back of the cup are painted three sphinxes and a hawk.

AN 1968.1835. Said to have been found at Cerveteri, Italy.
D: 33 cm

Lit.: H.W. Catling, *Archaeological Reports for 1974–75*, 33, No. 35, fig. 10; *GV* No. 11

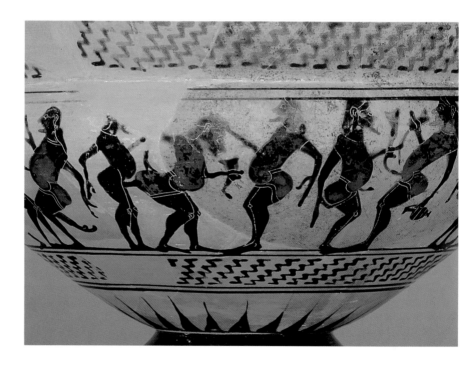

8 Pyxis
Corinth, 7th–6th century BC

This vessel has been used as an ash-urn, and still contains the charred bones of a woman. Pyxides usually, however, served as cosmetic jars. The decoration of the body, with two rows of animals, many of them mythological (sirens, griffin-birds, swans, griffin, panther), is normal but the presence of moulded female busts supporting the rim is slightly unusual. The heads resemble in general terms those of contemporary statues of maidens (*korai*).

AN 1893.125 (V. 183).
Gift of B. Belcher.
H: 19.5 cm

Lit.: H. Payne, *Necrocorinthia* (1931) 307, No. 888, pls. 28.12, 48.11; *GV* No. 12. On the cremated remains, see M. Becker, *Old World Archaeology Newsletter* 19 (1996) 5–8

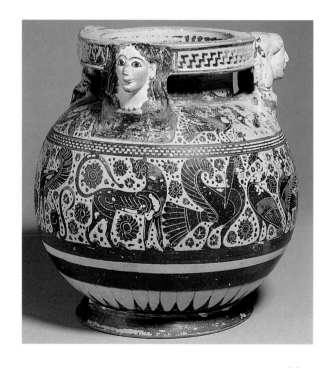

9 Oinochoe
Athens, 'black-figure' technique, 6th century BC

A skeuomorph of a sheet metal vessel, but with figure decoration derived, it would seem, from textile decoration: the filling ornament provides the clue. The large, bold, figure of a ram is characteristic of much Athenian ceramic decoration.

AN G. 204 (V. 505).
Found at Laurium,
Attica. Gift of
Sir Arthur Evans.
H: 32.4 cm

Lit.: CVA 2, IIIh,
pl. 13.1, 2; ABV 10.4
(attributed to 'the
manner of "the Gorgon
Painter"'); GV No. 13

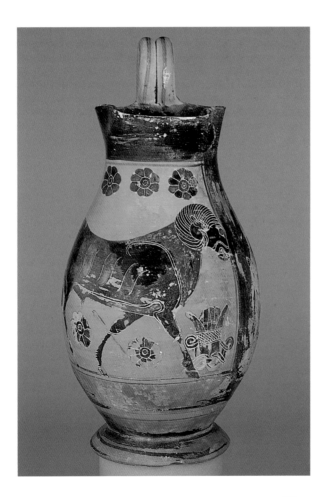

10 Plate
Athens, 'black-figure' technique,
6th–5th century BC

Heracles and Apollo fight over a deer, with Artemis apparently attempting to part them. The god and the hero draw bows on one another. The scene is unparalleled and the legend does not appear in the literary sources. Artemis, however, was the guardian of the Cerynaean hind, and there may be a reference to that myth here. The cock-fight in the exergue serves as a kind of parable to the scene represented above. The rim is decorated with a series of buds.

AN 1934.333. Found in Greece. D: 22.8 cm

Lit.: *ABV* 115.4 (attributed to 'the manner of "Lydos"'); F. Brommer, *Herakles* (1972) 22, pl. 16; *GV* No. 14

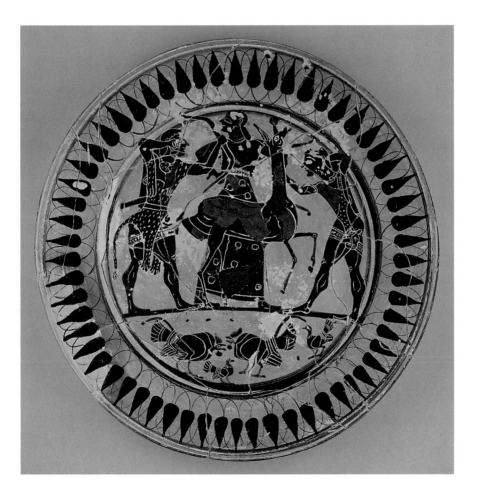

11 Column-crater
Athens, 'black-figure' technique,
6th–5th century BC

Craters were used by the Greeks to mix their wine with water (it was considered unhealthy to drink wine neat); we might compare the scene on No. 17, where a column-crater is in use. The decoration here consists of a four-horsed chariot seen from the front, with a charioteer and four bearded onlookers, two of them elderly. On the back is a sphinx with outspread wings between lions, and there are flying birds beneath the handles; motifs taken from the orientalising repertoire. On the upper surface of the handle plates are the heads of bearded men. There is a good deal of added purple and white, reminders of copper and ivory decoration on a bronze and silver version.

AN G. 209 (V. 190).
Found at Gela, Sicily.
H: 41.8 cm

Lit.: *CVA* 2, IIIh,
pl. 12.1–4, 8; *ABV* 124.
16 (attributed to 'the
Painter of Louvre F6');
GV No. 15

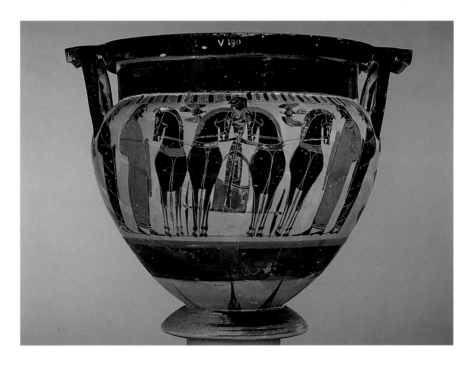

12 Amphora
Athens, 'black-figure' technique,
6th–5th century BC

The story of Theseus and the Minotaur is well known: how King Minos of Crete exacted an annual tribute of youths and maidens from Athens whom he would cast into the Labyrinth inhabited by the Minotaur, a creature half-man and half-bull. The prince Theseus persuaded his father to allow him to go to Crete as one of the party and, with the aid of Ariadne and her thread, entered the Labyrinth and slew the beast.

AN 1918.64. Bought with the aid of Miss Winifred Lamb.
H: 48 cm

Lit.: *CVA* 2, IIIh, pl. 4.3, 5; *ABV* 296.5 ('recalls "the Painter of Berlin 1686"'); *GV* No. 16

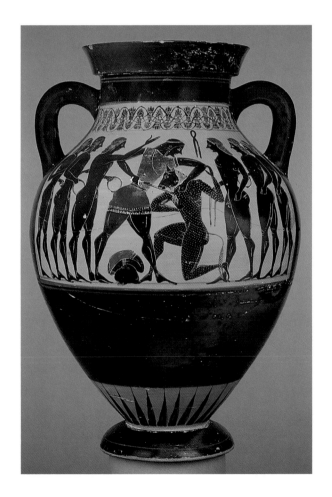

13 Band cup

Athens, 'black-figure' technique,
6th–5th century BC

Cock-fighting was encouraged among young men at Athens as a paradigm for warlike aggression. On this delicately drawn cup the cocks are spurred and excited as they prepare to fight with hens looking on. On the back is a browsing stag between two sirens. After the cup was fired, a hole was bored through from the bowl to the foot, and two smaller holes made in the stem of the latter: the reason may have been to make the cup into a 'dirty trick pot', to be used by a symposiast with a puerile sense of humour. The larger hole would have held a stopper, kept in position by means of a pin which passed through the smaller holes below. We have then to imagine a string attached to a pin, and a practical joker at the other end of the string. One tug, and the unfortunate victim would be drenched with the wine that poured through the hole.

AN 1964.621. Found at Vulci, Italy. H: 13.7 cm, D: 19.4 cm

Lit.: J. D. Beazley, *Paralipomena* (Oxford, 1971) 75.43 bis (attributed to 'the Tleson Painter'); M. Vickers, *American Journal of Archaeology* 84 (1980) 183–184, pl. 29; *GV* No. 18

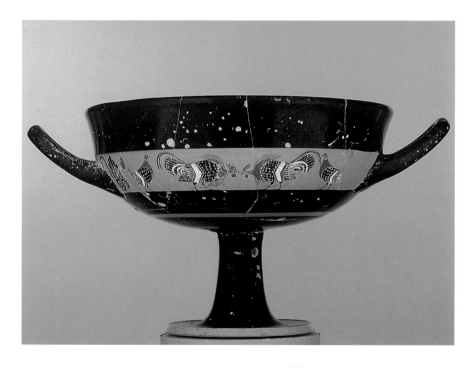

14 Oinochoe
Athens, 'black-figure' technique,
6th–5th century BC

There is a certain 'delicate touch and wit' in the detailed decoration of the clothing on this vessel, and the pot-bellied dancers. The scene is a dance at a symposium – a drinking party, for which an oinochoe (literally, a wine-pourer) would be a useful vessel to have around. There is one being dipped into a crater on No. 17. The flute-girl plays on the aulos, a reed instrument like a clarinet. Her flesh, as was customary in black-figure for women, is rendered in added white paint (an allusion to ivory inlay). The palmette painted beneath the handle has a purple centre: the ceramic vestige of a copper rivet on a silver analogue.

AN 1965.122. Formerly Rycroft, Spencer-Churchill collection.
H: 23 cm.

Lit.: *ABV* 154.45 (attributed to 'the Amasis Painter'); *Spencer-Churchill* 10, No. 55, pl. 8; *GV* No. 20; D. von Bothmer, *The Amasis Painter and his World* (Malibu, 1985) 160–2, No. 36; *Artful Crafts*, 143, figs. 5.29, 31

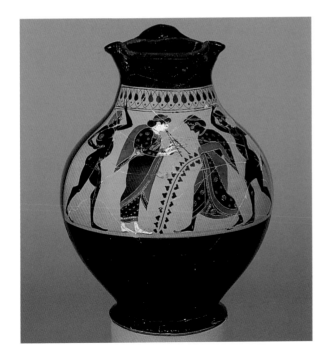

15 Amphora
Athens, 'black-figure' technique,
6th–5th century BC

Heracles, dressed in a carefully incised lionskin, assists Athena, Athens' tutelary deity, to mount her chariot. There is an inscription ('Herakleous kore' [= daughter of Heracles]) in the background which has attracted much discussion. It does not make sense applied to Athena (who was Heracles' half-sister), but probably identifies the fountain-house in the background: there was a fountain dedicated to Macaria, daughter of Heracles, which fed the marsh at Marathon. The Athenians encamped in one shrine of Heracles on the eve of the battle, and in another on their return to Athens.

AN 1885.668 (V. 212). Found at Cerveteri, Italy. Formerly Castellani collection. Present height: 56.4 cm

Lit.: *CVA* 2, IIIh, pls. 8.5–6, 7.9, 9.3; *ABV* 331.5 (attributed to 'the Priam Painter'; J. Boardman, *Revue Archéologique* 1972, 57–72; *GV* No. 21

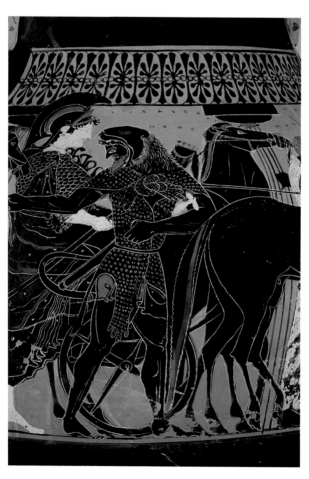

16 Amphora
Athens, 'black-figure' technique,
6th–5th century BC

Hermes bids farewell to Zeus. Both employ stylised gestures. Hermes wears a short chiton, a belted fawnskin, a cloak, a traveller's hat, and winged boots. In his left hand he carries his customary attribute, the caduceus. Zeus's garments are ornate (as are those of his attendants): decorated with numerous purple dots, and white rosettes. Zeus is enthroned on an elaborate chair which has lions' feet and a swan's-neck back; a figure of a panther stands on a rung between the legs. Inlaid ivory decoration on the throne is done with added white.

AN G. 268 (V. 509).
Oldfield bequest.
H: 41.8 cm

Lit.: *CVA* 2, IIIh, pl. 11;
ABV 239.5;
H. Mommsen, *Der Affecter* (Mainz, 1975)
No. 38, pls. 4, 44–45;
GV No. 22

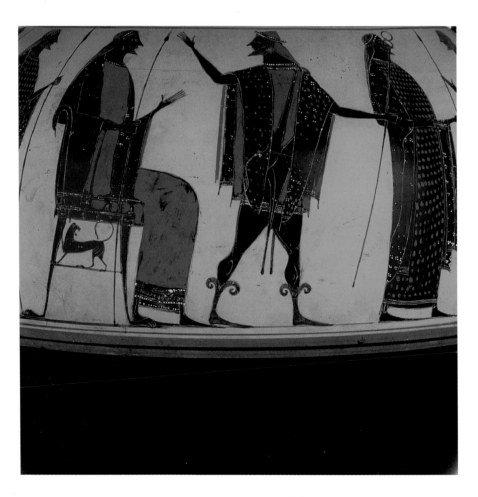

17 Cup-skyphos
Athens, 'red-figure' technique,
6th–5th century BC

Two naked servants kneel by a column-crater; one dips his oinochoe, and the other holds a cup in one hand and a skyphos in the other. On the back, a boy leads a pair of horses. The cup is decorated in the new 'red-figure' technique which evoked the 'gold-figure' decoration of fashionable silver vessels. While it is true that one of the criteria of kitsch is that if a cheaper material imitates a more expensive one, it is in bad taste, it is better perhaps to admire the skill with which the craftsman has ennobled his cheap raw materials. Some of the decorators of pots were very able draughtsmen (and, presumably, draughtswomen).

AN G. 276 (V. 520). Formerly Pourtalès collection, Oldfield bequest. H: 9.5 cm, D: 17.3 cm

Lit.: CVA 1, pl. 41.9–10; ARV² 76.84 (attributed to 'Epiktetos'); GV No. 23–4; P.R.S. Moorey, 'The technique of gold-figure decoration on Achaemenid silver vessels and its antecedents', Iranica Antiqua 23. 231–46; Artful Crafts 129–36

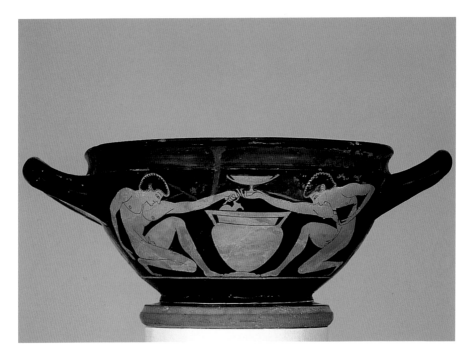

18 Lekythos

Athens, 'red-figure' technique,
6th–5th century BC

Two men and a woman are seated on folding stools, apparently engaged in a lively conversation. All wear a chiton (= a light, full-length garment) and himation (= a cloak or wrap) and the men have wreaths on their heads, but the woman has her hair done in a simple ribbon. The folds of the garments, which are decorated with dot-rosettes are drawn in a way which recalls those on contemporary sculptured figures. The shoulder is decorated with three palmettes, linked by thin curving tendrils.

AN 1949.751 gift of
L.J.E. Hooper.
Preserved height:
16.8 cm

Lit.: *ARV²* 9.1 (attributed to 'the Painter of Oxford 1949'); D.C. Kurtz, *Athenian White Lekythoi* (1975) 10, 13, 199, pl. 5.1

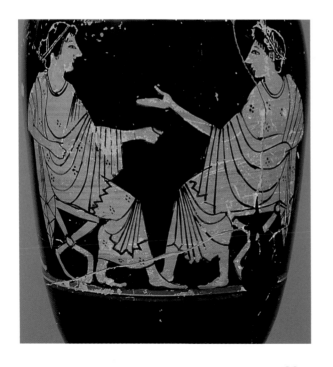

19 Cup

Athens, 'red-figure' technique,
6th–5th century BC

In the tondo, a naked slave-girl walks carefully lest she
spill the contents of the wine cup (note too, the ladle
with a duck's-head handle). She is clearly a servant at a
symposium, perhaps a secular analogue for the rape of
Antiope shown on the outside. In legend, Theseus king
of Athens took part with Heracles in a war against the
Amazons (legendary female warriors), and won one of
them, Antiope, for himself. Here, a get-away chariot is
waiting, a young driver at the reins. Theseus carries his
Amazonian booty, at the run, followed by two accom-
plices. On the other side, the alarm is given by a trum-
peter, and an Amazon dressed as a hoplite (a heavily
armed soldier), and Amazons on horseback (dressed in
Persian hats and trousered combinations) come running
in an attempt to save their companion.

AN 1927.4065.
Formerly
Holford collection.
Bought with the aid of
Miss E. R. Price.
H: 12.6 cm, D: 32.8 cm

Lit.: *CVA* 2, IIIi,
pls. 51.4, 53.3–4; *ARV²*
62.77 (attributed to
'Oltos'; E. D. Francis,
*Image and Idea in
Fifth-Century Greece*
(London, 1990)
figs 29–30

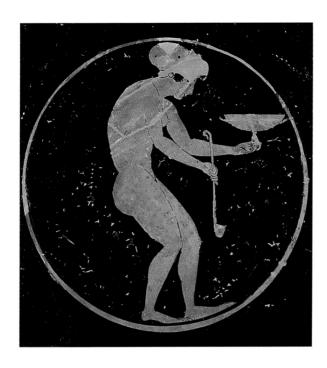

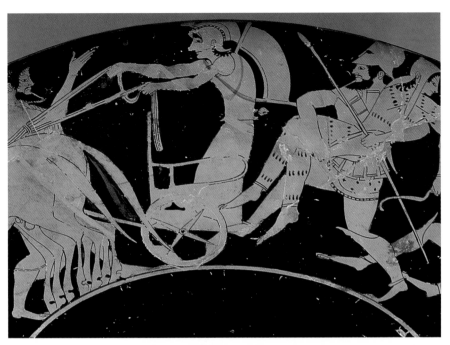

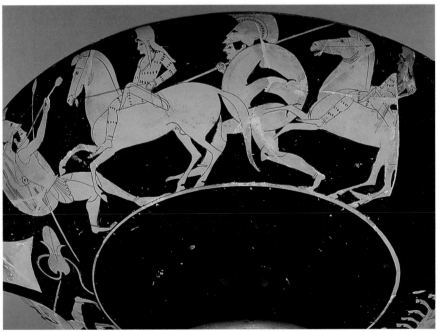

20 Amphora of Panathenaic shape
Athens, 'black-figure' technique,
6th–5th century BC

Panathenaic amphoras were made (always in the black-figure technique) in order to hold the oil that was given as the prize at the quadrennial games at Athens. The victor in the *stadion* (foot race) would receive 100 amphorasful. Silver Panathenaic amphoras are mentioned in the ancient sources. The plentiful pottery examples regularly show on one side an armed Athena standing between a pair of columns surmounted by cocks, and on the other a scene of chariot or foot racing, discus throwing, wrestling, boxing etc.

AN 1965.117. Formerly Depoletti, Spencer-Churchill Collection. H: 49.5 cm

Lit.: *ABV* 307.60 (attributed to 'the Swing Painter'); *CVA* 3, pl. 27; *GV* No. 29

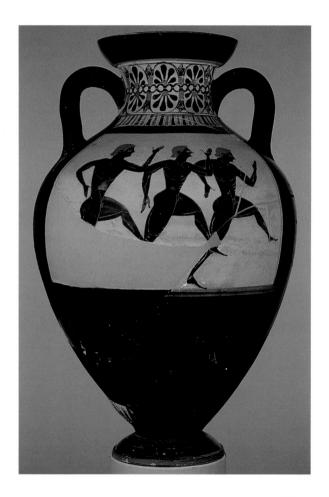

21 Stamnos
Athens, 'black-figure' technique,
6th–5th century BC

Tubby boxers are shown on the reverse of this pot; equally tubby runners on the front. The latter resemble those on No. 20, apart from the fact that they are bearded and wear loin-cloths *(perizomata)*. The loin-cloths, in added white, are a prominent feature too of the reverse, where the elderly boxers slam it out beneath the watchful eye of an umpire who holds a long forked stick with which to indicate a fault. Another boxer binds his hands with the leather thongs which served in classical antiquity for boxing gloves. On the shoulder, a symposium, exceptionally attended by women who are shown on equal terms with the men.

AN 1965.97. Formerly Spencer-Churchill collection. H: 17.3 cm

Lit.: *ABV* 343.6 (attributed to 'the Michigan Painter'); *Spencer-Churchill* 12, pl. 12, No. 68; *GV* No. 30

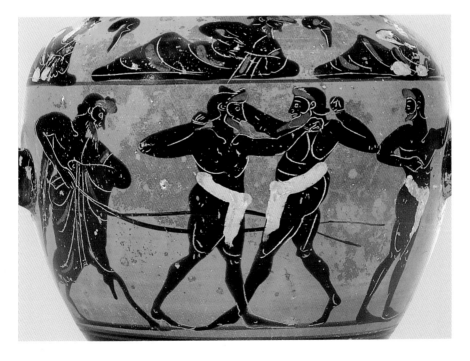

22 Lekythos
Athens, 'black-figure' technique, 5th century BC

A ball game: a bearded man leaning on a stick is about
to throw a ball towards a line consisting of three youths
each mounted on a companion's shoulders. There is a
graffito *'keleuson'* – 'call for it' inscribed in the field.

AN 1890.27 (V. 250)

Lit.: C.H.E. Haspels,
*Attic black-figured
Lekythoi* (1936) 216.2
(attributed to 'the
Edinburgh Painter');
GV No. 31; E. Böhr, *Der
Schaukelmaler* (Mainz,
1982) pl. 197b–c

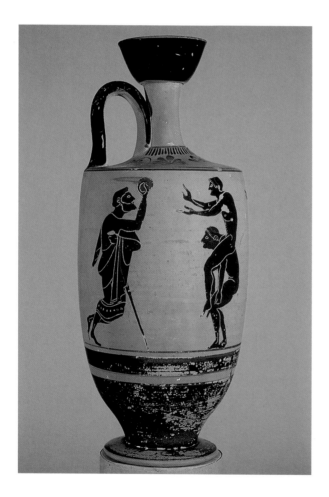

23 Pelike

Athens, 'black-figure' technique, 5th century BC

Scenes of men at work are not very common on Greek pots, but there are several examples in the Ashmolean (e.g. Nos 28, 32, and 40). Here we see a shoemaker cutting a piece of leather round the foot of a customer. Beneath the table is a bowl of water with which the leather would be wetted before cutting. Above the shoemaker is a rack containing, from left to right, two knife blades with the tangs showing, a knife like the one that the shoemaker is using, and a clicker's knife. A shoemaker's establishment has actually been found near the Athenian agora.

AN G. 247 (V. 563). Found on Rhodes, Greece. H: 40 cm

Lit.: *CVA* 2, IIIh, pl. 8.7–8; *ABV* 396.21 (attributed to 'the Eucharides Painter'; D. B. Thompson, *Archaeology* XIII (1960) 234–240; *GV* No. 32

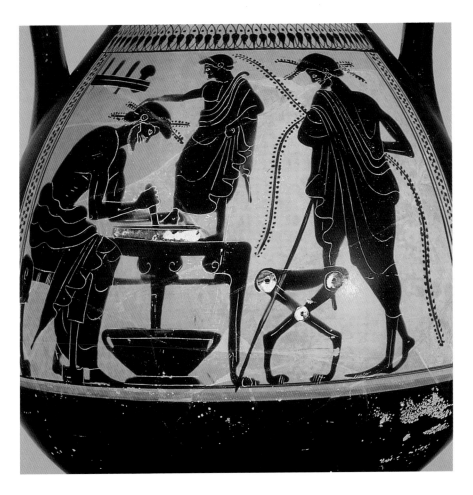

24 Cup
Athens, 'black-figure' technique, 5th century BC

The interior of this cup is decorated with a Gorgon's-head tondo, around which is a symposium attended by six men who recline feasting beneath vines. They all wear himatia arranged over their legs; two wear ivy wreaths and three turbans evocative of Ionia. Some hold drinking vessels and there are musical instruments – an aulos (cf. No. 14) and a lyre. One man is about to spank a boy with a slipper. The usual elements of the Greek symposium are thus here: drinking, music-making and rowdyism. A further aspect, eroticism, is emphasised by the presence on the underside of an unusual foot made in the form of a penis and testicles.

AN 1974.344. Formerly Bomford collection. H: 12.5–13.8 cm, D: 34 cm

Lit.: J. Boardman, *Archäologischer Anzeiger* 1976, 281–290 (attributed to 'the manner of "the Andocides Painter"'); *Anzeiger* 1981, 544–545; GV No. 33

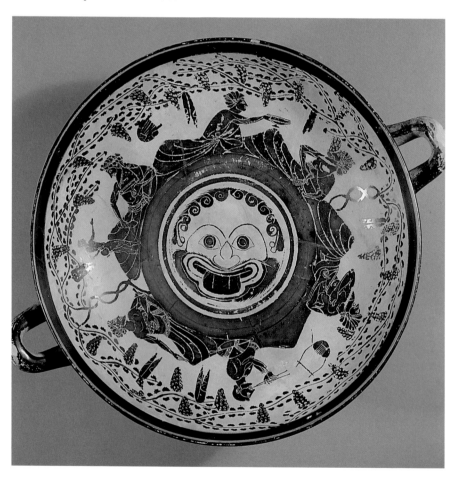

25 Head vases
Athens, 5th century BC

Head vases were made in several forms at Athens, but satyrs and maenads are among the most frequent. The vessels that are thus adorned were used for the serving and drinking of wine; a satyr's head makes sense in this context (for satyrs were the attendants of Dionysus, the wine-god), and maenads were the constant companions of satyrs (there are even some head vases with satyrs and maenads back to back). The maenad here is especially attractive, with her stylised curls, her elegant eyebrows and carefully outlined lips. In a metal version, the hair would consist of small ivory cones held in place by means of silver pins.

Left: AN 1920.106.
H: 15 cm

Lit.: *CVA* 1, IIIi,
pl. 44.1–2; *ARV²* 1532.1
(attributed to 'the
Oxford Class'); *GV*
No. 34

Right: AN 1946.85.
Formerly Hope
collection.
Gift of W.H. Buckler.
H: 15 cm

Lit.: *ARV²* 1546.3
(attributed to 'the
Chairete Class'); *GV*
No. 34

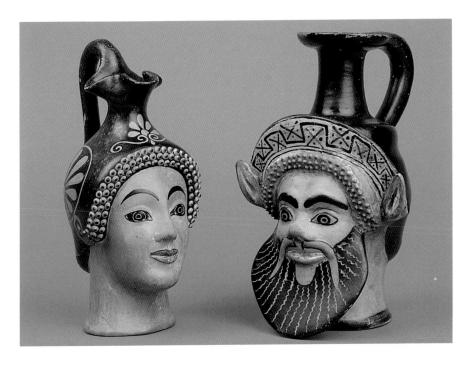

26 Cup
Athens, 'red-figure' technique, 5th century BC

The only decoration on this cup is in the tondo, where a Laconian (Spartan) hound is shown scratching itself. The designer of this image (in the first place presumably for 'gold-figure' work on silver) created a very elegant design, with the curve of the dog's back and neck rhyming with the curve of the edge of the tondo, and the loop of its tail with the calligraphic line on the shoulder. Laconian hounds were the usual kind of hunting dog used in Greece, though there seem to have been at least two breeds: the smooth-haired (as here) and the rough.

AN 1966.447. Found in Italy. Gift of Sir John Beazley. H: 6.5 cm, restored diameter: 18 cm

Lit.: *ARV²* 96.136 (attributed to the 'Euergides Painter'; *Beazley Gifts* 54, pl. 19, No. 164; P. Rouillard, *Revue Archéologique* 1975, 43. On Laconian hounds, see C. M. Stibbe, *Mededelingen van het Nederlands Instituut te Rome* XXXVIII (1976) 9; *GV* No. 35

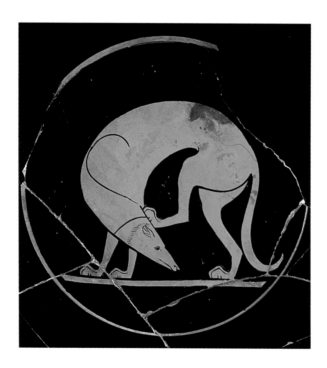

27　Cup
Athens, 'red-figure' technique, 5th century BC

Work and play combined: a boy carries a plate of food covered with a napkin in one hand, and trundles a hoop along with the other. Like the Laconian hound tondo (No. 26), this is a masterpiece of tondo composition, this time using the whole circle instead of resting the figure on an exergue.

AN 1886.587 (V. 300).
Found at Chiusi, Italy.
Gift of Sir Arthur
Evans. H: 7.8 cm,
D: 19.6 cm

Lit.: *CVA* 1, IIIi, pl. 1.8;
ARV² 357.69 (attributed
to 'the Colmar Painter');
GV No. 37; D. Vanhove
(ed.), *Le sport dans la
Grèce antique* (Brussels,
1992) 160, 168, No. 12

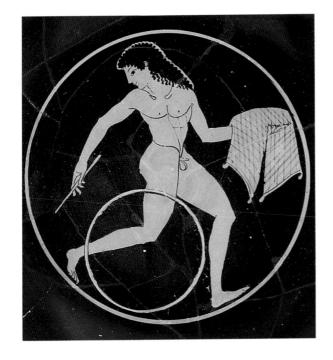

28 Cup
Athens, 'red-figure' technique, 5th century BC

A young helmet-maker crouches on a low stool, putting the finishing touches with a file to a Corinthian helmet. Unfortunately, the whole of the central part of the scene is missing and has had to be restored. Thus the lower part of the young man's head, his chest and arms, as well as most of the file and the cheekpiece of the helmet are modern. In front of him is an anvil set in an anvil-block, and behind him a furnace with a cauldron set upon it. Above is a row of five files of different shapes; we might compare the shoemaker's tools in No. 23. The pot was broken and mended in antiquity: it was clearly 'not done' to place a broken pot in the tomb.

AN G. 267 (V. 518). Found at Orvieto, Italy. Formerly Bourgignon collection. D: 24.3 cm

Lit.: CVA 1, IIIi, pl. 2, 8 (with most restorations deleted); ARV² 336.22 (attributed to 'the Antiphon Painter'); GV No. 39

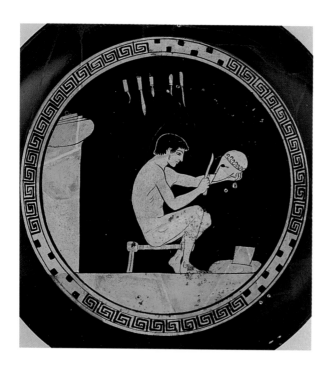

29 Cup

Athens, 'red-figure' technique, 5th century BC

There is an arming scene on the front of this cup; on the back, a fight between Greeks and Persians: in the centre a Greek lunges at a Persian who collapses at the onslaught; to either side more evenly balanced battles occur. The battle on the right (shown here) involves a Greek attacking a Persian who defends himself with a raised spear and a rectangular shield.

AN 1911.615. Found at Cerveteri, Italy. Gift of E. P. Warren and incorporating a fragment of New York, Metropolitan Museum of Art 1973.175.2, through the good offices of Dr Dietrich von Bothmer. D: 33 cm

Lit.: *ARV²* 399 (attributed to 'the Painter of the Oxford Brygos'); A. A. Barrett and M. Vickers, *Journal of Hellenic Studies* XCVIII (1978) 17–24, pls. 1–2; *GV* No. 40

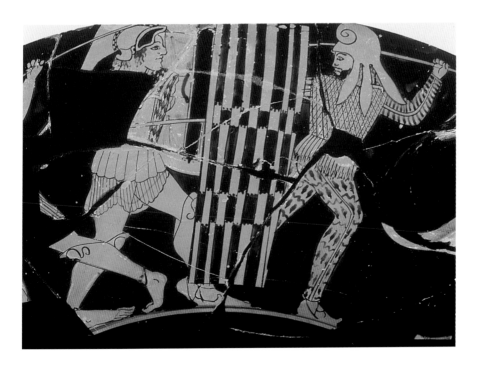

30 Stamnos
Athens, 'red-figure' technique, 5th century BC

Historically, Maenads were ordinary housewives who had abandoned their families to join secret female societies known as *thiasoi*, which convened at set intervals and roamed about the countryside leading the life of animals. Here we see the mythological variety at the moment when they have torn apart Pentheus, a young man who had the misfortune to be caught watching their rites. The event has added poignancy for Pentheus's mother was among the initiates. She holds aloft his head, others wield arms and legs, and one a mass of entrails.

AN 1912.1165. Found at Cerveteri, Italy. Gift of E. P. Warren. Restored height: 33.4 cm

Lit.: *CVA* 1, IIIi, pls. 25.1–2, 20.10–12, 30.5–6; *ARV*² 208.144 (attributed to 'the Berlin Painter'); *GV* No. 41

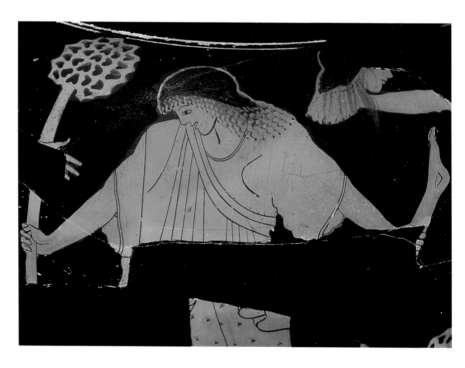

31 Lekythos
Athens, 'red-figure' technique, 5th century BC

A winged Nike, or goddess of Victory, is shown on the wing and holding a cithara which she plucks with a plectrum attached by a purple cord to the instrument. This pot once made an impression on sensitive souls. W.B. Yeats enthused: 'I recall a Nike at the Ashmolean Museum with a natural unsystematic beauty, like that before Raphael . . .'. Lekythoi were used as containers for oil; silver examples are recorded at Acragas in Sicily, and 'gold-figure' specimens were doubtless made in silver-rich Athens. The mouldings on this vessel show that it was intended to resemble a metal oil jar.

AN 1888.1401 (V. 312). Found at Gela, Sicily. Gift of Sir Arthur Evans. H: 35 cm

Lit.: W.B. Yeats, *A Vision*; CVA 1, IIIi, pl. 33.2; *ARV²* 556.102 (attributed to 'the Pan Painter'); *GV* No. 44

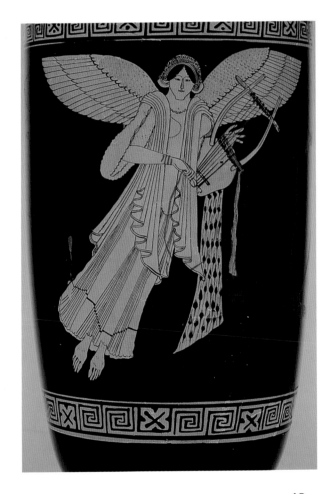

32 Pelike
Athens, 'red-figure' technique, 5th century BC

A youth carries a couch and a three legged table on his back. It looks as though he is getting ready for a symposium, for this was the regular furniture employed on such occasions. The guests would recline on couches and food would be served on small tables placed in front. When the serious drinking started (after the meal), the tables would be removed or pushed beneath the couches.

AN 1890.29 (V. 282).
Found at Gela, Sicily.
H: 28.4 cm

Lit.: *CVA* 1, IIIi, pl. 19.1 and 4; *ARV²* 555.87 (attributed to 'the Pan Painter'); *GV* No. 45

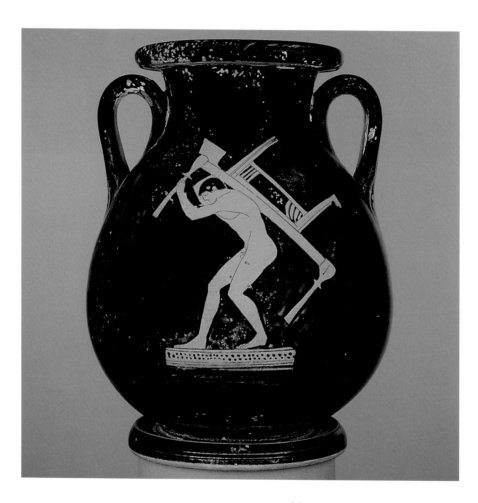

33 Stamnos
Athens, 'red-figure' technique, 5th century BC

Busiris King of Egypt consulted a soothsayer when his kingdom was devastated by a drought. He was told that the scourge would only cease if each year he sacrificed a stranger. Busiris began by sacrificing the soothsayer and continued until Heracles arrived in Egypt and was chosen as a victim. His throat was about to be cut when he burst from his chains and killed Busiris and his attendants. These were regularly shown as Africans, as here. Busiris is probably the one that Heracles has by the throat at the altar against which the sacrificial knife leans. The handles appear to be placed over the picture: an indication perhaps of the potter's dependence on work in another medium.

AN G. 270 (V. 521). Found at Vulci, Italy. Formerly Canino collection, Oldfield bequest. H: 36.5 cm

Lit.: *CVA* 1, IIIi, pls. 26.1–4, 31.5; *ARV²* 216.5 (attributed to a late follower of 'the Berlin Painter' [the Group of London E311]); *GV* No. 46

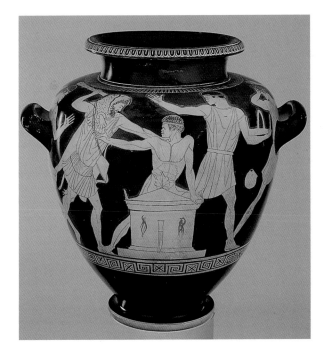

34 Lekythos
Athens, 'red-figure' technique, 5th century BC

A stately image of Apollo and Artemis, brother and sister deities, each with their attribute: Apollo with his lyre (made from a resonating tortoise-shell), and Artemis with her hind.

AN G. 292 (V. 535)

Lit.: *CVA* 1, IIIi, pls. 35, 1–2; 38.14

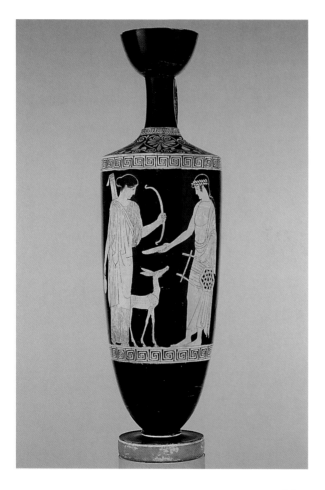

35 Volute-crater
Athens, 'red-figure' technique, 5th century BC

Pandora had been fashioned from clay and water by Athena and Hephaestus, and was endowed by the gods with their attributes, but Hermes put perfidy into her heart and lies into her mouth. Zeus then sent her as a gift to Epimetheus who, despite warnings, was so entranced by Pandora's beauty that he welcomed her. Here Pandora rises from the ground before the love-stricken Epimetheus.

AN G. 275 (V. 525).
Formerly Crouel de Prez collection, Oldfield bequest. H: 48.2 cm

Lit.: *CVA* 1, IIIi, pl. 21. 1–2, 32.6; *ARV²* 1562.4 (said to be related to 'the Group of "Polygnotos"'); *GV* No. 48; E.D. Reeder (ed.), *Pandora: Women in Classical Greece* (Baltimore, 1995) 284–6, No. 81

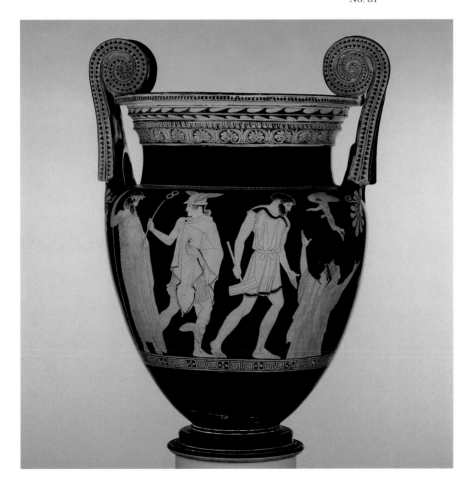

36 Pelike

Athens, 'red-figure' technique, 5th century BC

When an Athenian joined the cavalry, he insured his
horse with the state for 1200 drachmas (equivalent to
more than £2000: the price of a decent horse today). The
youth on this pottery vessel rides such a horse bareback.
The painting has been attributed to 'the Achilles Pain-
ter', whose work is said to have been 'highly regarded
. . . in antiquity'. But this cannot be, for an inscription on
the underside (4 items for 3.5 obols) gives a price equiv-
alent to 25p; scarcely the stuff of connoisseurship or
artistic patronage. Whoever he (or she) may have been,
'the Achilles Painter' was not considered to be a great
artist by contemporaries.

Anonymous loan

Lit.: *Artful Crafts*, 87,
figs 4.3–4

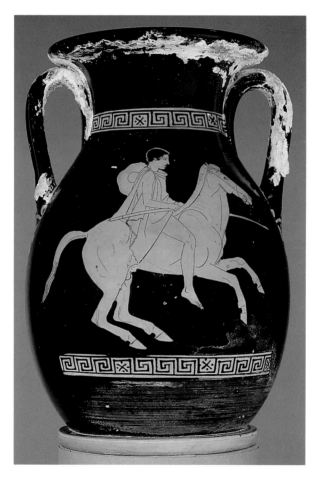

37 Hydria
Athens, 'red-figure' technique, 5th century BC

The Thracian bard Thamyras appears at the moment when he was deprived of sight and voice and the power of playing the lyre for having boasted that he would rival the Muses. His anguished mother Argiope (wearing Thracian dress and tattoo marks) and a haughty Muse look on. The way that Thamyras is shown above the ground-line may be an echo of a device that was introduced into mural painting shortly before the mid-fifth century in order to indicate spatial regression. The scene may relate to Sophocles' lost drama *Thamyras*.

AN G. 291 (V. 530).
Found in Greece.
H: 28 cm

Lit.: *CVA* 1, IIIi, pl. 32.1;
ARV² 1061.52
(attributed to 'the
Group of
"Polygnotos"');
A.D. Trendall and
T.B.L. Webster,
*Illustrations of Greek
Drama* (1971)
70 (fig.)–71; *GV* No. 50;
K. Zimmermann,
'Tätowierte Thrakerin-
nen auf griechischen
Vasenbildern',
*Jahrbuch des deutschen
archäologischen
Instituts* 95 (1980)
188–9, figs 23a–b

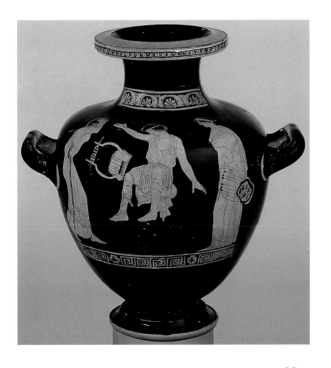

38 Lekythos
Athens 'white-ground' technique, 5th century BC

A woman and a youth stand by a high stele set on a stepped base. The woman holds a plemochoe (a vessel for perfume) in her right hand and an alabastron in her left. Her hair is tied up in a scarf and she wears a red himation. The youth is dressed in a grey himation, and it is possible to see the lines of his body through the fugitive paint. White-ground lekythoi (which probably owe both their form and colour to painted ivory vessels: see No. 39) come closest of all decorated pots to mural painting.

AN 1896.41 (V. 545). Found at Laurium, Attica. H: 36.3 cm

Lit.: *ARV²* 998.165 (attributed to the 'Achilles Painter'); D. C. Kurtz, *Athenian White Lekythoi* (1976) 38, 40, 46, 51, 214, pl. 36.2; *GV* Nos. 52–3

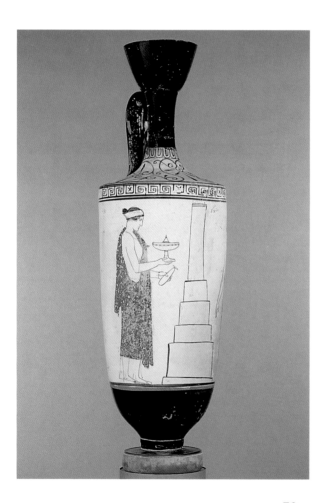

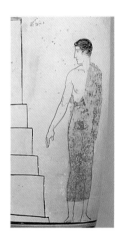

39 Lekythos
Athens, 'white ground' technique,
5th century BC

In order to cross the river Acheron in the Underworld, it was necessary to apply to Charon, the official ferryman. His fee was an obol (a small silver coin), and the Greeks therefore occasionally placed an obol in the mouths of the dead. Here we see Charon in his boat on the reedy banks of the river receiving the soul of a dead person which is shown as a small winged creature.

AN G. 258 (V. 547). Found in Athens. H: 22 cm

Lit.: *ARV*² 756.64 (attributed to 'the Tymbos Painter'); D.C. Kurtz, *Athenian White Lekythoi* (1976) 63, n. 6; *GV* No. 51

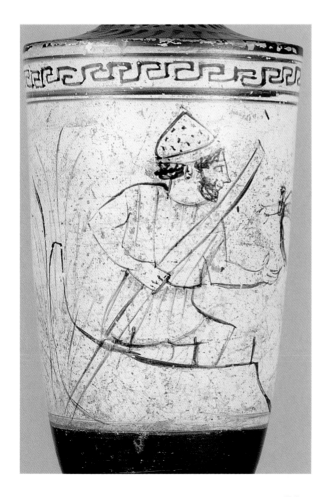

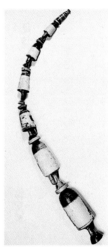

Pottery lekythoi arranged to show the derivation of the shape from ivory

51

40 Bell-crater
Athens, 'red-figure' technique, 5th century BC

Another pot with men at work (cf. Nos, 23, 28 and 32), this time showing the interior of a potter's workshop. From left to right, a youth sits painting a bell-crater black with a large brush. His slip stands in a skyphos on a low table beside him; another youth carries off a finished bell-crater into another part of the workshop where a third crater stands on the ground; a third youth carries a skyphos in his hand.

AN G. 287 (V. 526). Found in Greece. H: 35 cm

Lit.: *CVA* 1, IIIi, pls. 24.2, 25.7; *ARV²* 1064.3 (attributed to 'the Komaris Painter'); *GV* No. 56

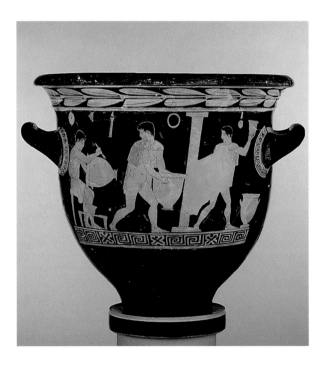

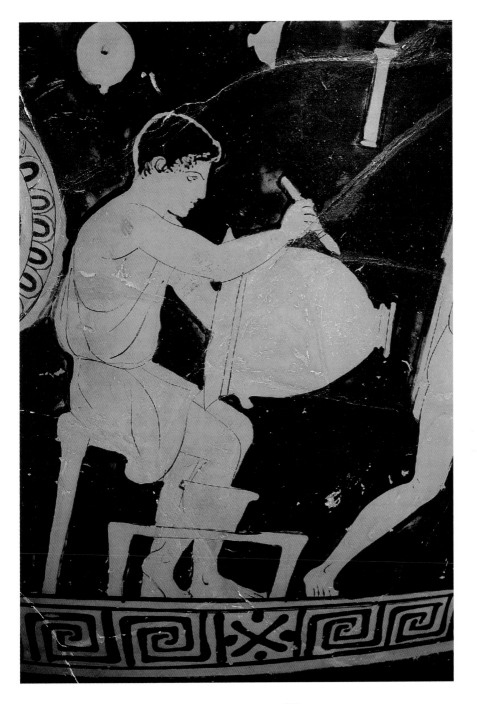

41 Calyx-crater
Athens, 'red-figure' technique, 5th century BC

This vessel is decorated with scenes from several Attic legends. In the upper zone six of Theseus's adventures appear: Theseus and Procrustes (illustrated below; Procrustes was a giant who forced his 'guests' to lie on a bed and if they were too short for it he would stretch them; if they were too long, he would chop off whatever overlapped. Theseus gave him a taste of his own medicine), Theseus and Skiron with Athena watching, Theseus and Sinis, Theseus lifting the rock to find his father's sword, Theseus and the Bull of Marathon, and Theseus and the Sow of Krommyon. In the lower zone in front, Prometheus brings fire from heaven in a stalk of giant fennel, and satyrs light torches at it; on the back, Eos pursues Kephalos. Many of the figures are identified by inscriptions.

AN 1937.983. Found in Spina, Italy. Bought with the aid of the National Art-Collections Fund. H: 39.5 cm

Lit.: *ARV²* 1153.13 (attributed to 'the Dinos Painter'); *GV* No. 57

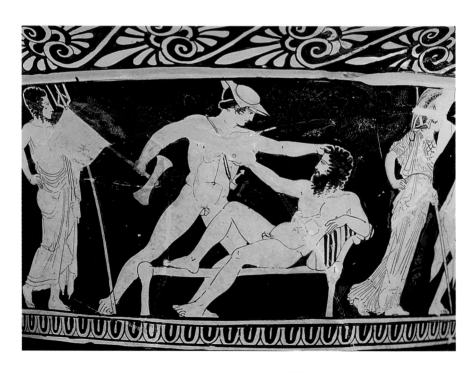

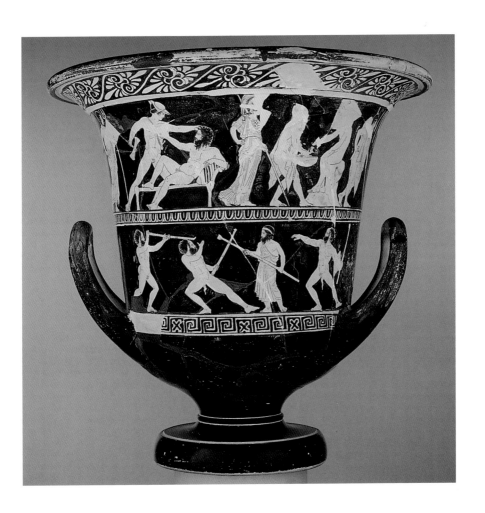

42 Amphoriskos
Athens, 'red-figure' technique, 5th century BC

A seated woman, with her hair loose, looks at herself in the mirror. Her feet rest on a footstool, and a perfume vessel is suspended behind her. On the other side, another woman, whose name Theano is written above her head, holds a ribbon in one hand and a jewel box in the other. There is a very delicate double-palmette pattern on each side beneath the handles of this miniature mock silver version of a trade amphora (see No. 60).

AN G. 303 (V. 537)

Lit.: *CVA* 1, IIIi, pl. 40, 3–5 *ARV*[2] 1248.10; A. Lezzi-Hafter, *Der Eretria-Maler* (Mainz, 1988) 345, pl. 160, figs 82a, 83a

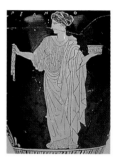

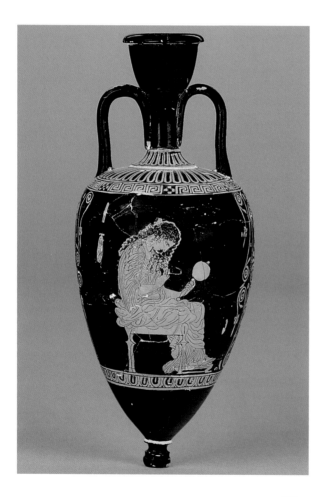

56

43 Pyxis
Athens, 'red-figure' technique, 5th century BC

This is a rendering in clay of a silver version of a shape, the pyxis, whose origins lie in treen or turned wood; the words pyxis, pyx, and box[wood] are cognate. A woman juggles apples, while her companion smells a flower. The scene on the other side shows women working wool.

AN 1965.130

Lit.: *ARV²* 864.15 (attributed to 'the manner of "the Pistoxenos Painter"'); *Spencer-Churchill* 13.79, pl. 15

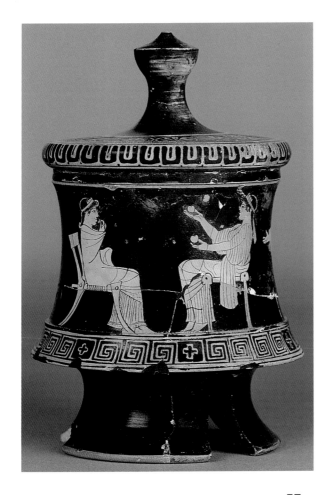

44 Oinochoe
Athens, 'red-figure' technique, 5th century BC

A winged Nike flies with a ribbon towards a tripod. Both are symbols of victory: Nike means 'victory' in Greek, and tripods were regularly given as prizes at games or were set up to commemorate victories in battle. This tripod, with its Doric columnar support appears to belong to the latter variety, and the original design may well have been devised to commemorate the successful outcome of a battle in the Peloponnesian War.

AN G. 280 (V. 533). Found at Nola, near Naples. Formerly Pourtalès collection, Oldfield bequest. H: 18 cm

Lit.: *CVA* 1, IIIi, pl. 43.3; *ARV²* 1263 ('near "the Calliope Painter"'); P. Amandry, *Études déliennes* (Paris, 1973) 37–38, fig. 25; *GV* No. 58

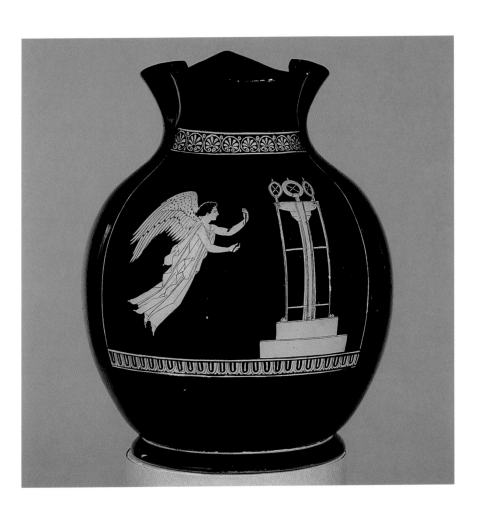

45 Pyxis
Athens, 'red-figure' technique,
5th–4th century BC

Pyxides were generally used for holding cosmetics or trinkets, and examples have been found with their contents still extant. This function explains the nature of the decoration on this example, highly suitable for the boudoir (although this is a cheap substitute for a precious metal example). Groups of women and Erotes (= Cupids) are painted on both the lid and sides; twenty-four figures in all. One group on the lid consists of an Eros, gazing into the face of a lady to whom he has just delivered a love-token. On the sides can be seen *inter alia* a seated woman holding up what could be a gem and admiring it (another lies in her lap); in front of her, a woman holding a box in one hand and a necklace in the other, and behind, a couple of woman listening with curiosity to their conversations. The Erotes are done in white, and many details, notably the jewellery and wings, are raised and gilt.

AN G. 302 (V. 551).
H: 9.35 cm, D: 19.7 cm

Lit.: *CVA* 1, IIIi,
pl. 46.1–7, 47.2; *ARV²*
1328.98; *GV* Nos.
59–60: L. Burn, *The
Meidias Painter*
(Oxford, 1987) 100, pls
49–50

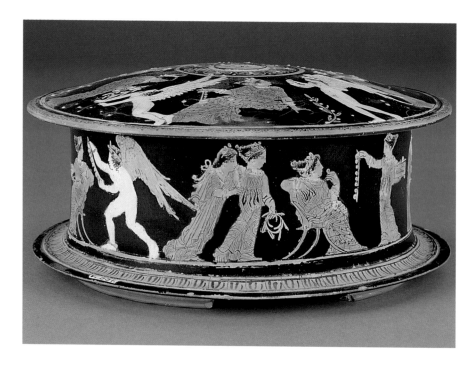

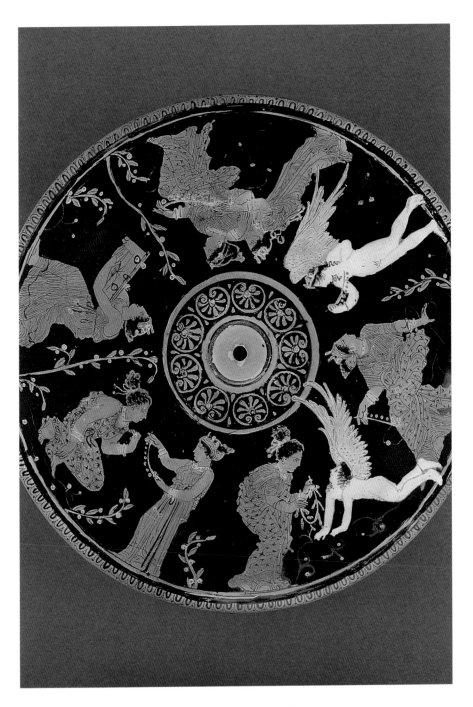

46 Skyphos
Boeotia, 'black-figure' technique,
5th–4th century BC

The 'black-figure' technique went out of fashion at Athens during the fifth century, apart from the decoration of vessels made for specific ritual purposes and vessels for the prize oil. Elsewhere, it continued to be used on vessels made in connection with the Cabiran sanctuary near Thebes, Boeotia. Many Cabiran vessels have slickly drawn comic scenes on them, as here. Odysseus, wearing a traveller's hat and with a sword in one hand and its scabbard in the other, is about to be given a dose of Circe's drugged potion. Behind the sorceress is her loom, the warp held taut by means of loom-weights. On the other side, Odysseus is blown by Boreas, the North Wind, across the sea on a raft made of amphoras (the ancient equivalent of oil drums; see No. 60). The marine aspect of the scene is enhanced by the representation of the waves, by the presence of fish, and by the fact that Odysseus holds a trident.

AN G. 249 (V. 262).
Found at Thebes,
Boeotia. H: 15.4 cm

Lit.: *GV* Nos. 62–63; J.-M. Moret, 'Circé tisseuse sur les vases du Cabirion', *Revue archéologique* (1991) 228–31, figs 1–3

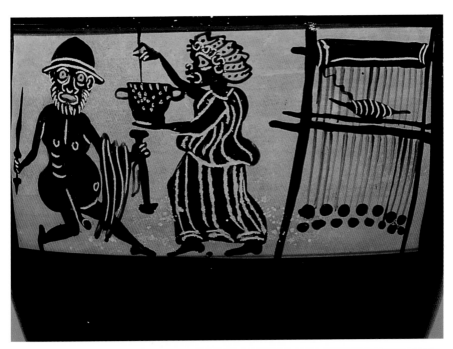

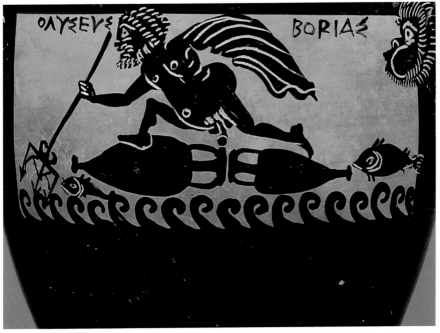

63

47 Stemless cup
Athens, 'red-figure' technique,
5th–4th century BC

The safety of Troy, besieged by the Greeks for ten years, depended on the Palladium, a statue of Pallas Athena. The Greek hero Diomedes, assisted by Odysseus, succeeded in capturing the sacred image, and here we see him carrying it out of its temple and past a flaming altar. Diomedes carries a sword in his right hand (he had to kill Athena's priest before he could succeed) and the Palladium, shown as an archaic statuette, in his left.

AN 1931.39. Found in Apulia (? at Valenzano). D: 16 cm, H: 5.5 cm

Lit.: *ARV*² 1516.1 (attributed to 'the Diomed Painter'); *GV* No. 61

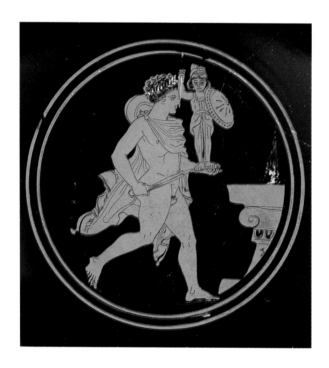

48 Pelike
Athens, 'red-figure' technique, 4th century BC

A device that is frequently employed on fourth-century
Athenian pots is to paint one or more of the figures on a
vessel white; as here in the case of the horse whose team
mate and driver are being attacked by griffins (the le-
gendary guardians of the Central Asiatic goldfields). We
can perhaps view such white figures as evoking ivory
inlay on silver vessels.

AN 1970.6. H: 28 cm

Lit.: H. W. Catling,
*Archaeological Reports
for 1974–75*, 31–32,
No. 27, fig. 8; *GV* No. 64

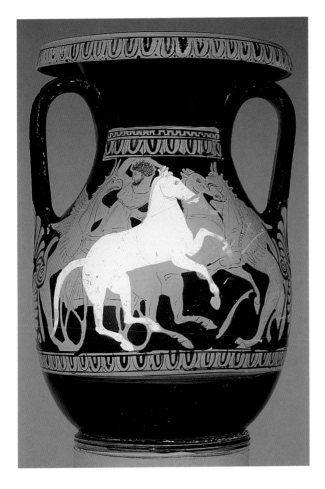

49 Pelike
Apulia, 'red-figure' technique, 4th century BC

The 'Ornate' style of Apulian painting is well represented on this vase with its elaborate floral decoration and its use of a great deal of added white. A bride is shown at her toilette. She is naked but for earrings, bracelets and an anklet. She is extracting perfume from an alabastron which she holds above a basin on a columnar stand. Her garments are placed on a stool behind her. She is assisted by three other women and a hovering Eros holds a wreath over her head. On the back are two women. a youth and Eros. The pot was broken and mended in antiquity as can be seen from the pairs of rivet holes. Tarentum, the chief city of Apulia, was very rich in the fourth century; this pot provides us with an idea, albeit at several removes, of how the precious vessels that the Tarentines possessed in great number might have looked.

AN G. 269 (V. 550). Found in Basilicata, Italy. Formerly Beugnot, Pourtalès collections, Oldfield bequest. H: 36.5 cm

Lit.: A. D. Trendall and A. Cambitoglou, *The Red-figured Vases of Apulia* 1 (Oxford, 1978) 399, pl. 140.1 (attributed to 'the Suckling Group'); *GV* No. 67

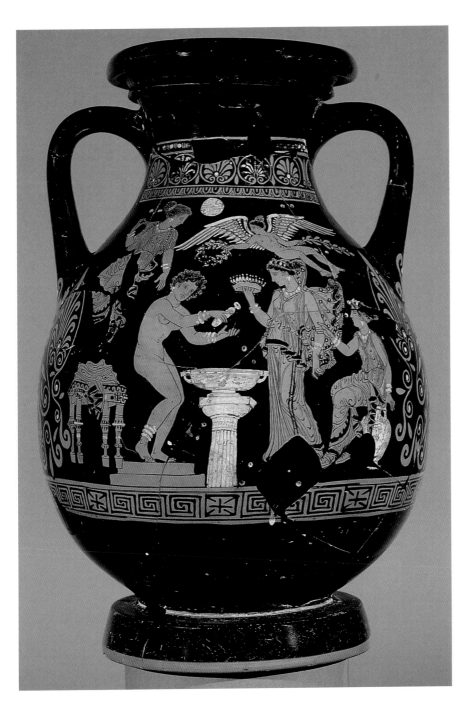

50 Hydria
Apulia, 'red-figure' technique, 5th century BC

After the middle of the fifth century Greek colonists in southern Italy began to use local wares made in imitation of Attic-style silverware. Tarentum was a major early centre, where this Apulian 'Plain' style vessel, showing women spinning and winding wool was made. Woolworking was the avocation of most females in the ancient Greek world. Women in any household would spend much of their time preparing cloth for their family's use.

AN 1974.343. H: 29 cm

Lit.: *Burlington* 1975, 390, fig. 89; *GV* No. 66; A.D. Trendall and A. Cambitoglou, *The Red-figured Vases of Apulia* 1 (1978) 8.14 (attributed to 'the Painter of the Berlin Dancing Girl'); cf. M. Vickers, *Images on Textiles: the Weave of Fifth-Century Athenian Art and Society* (Konstanz, 1999)

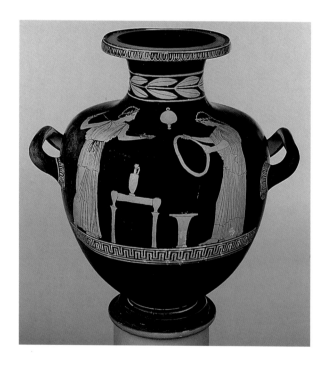

51 Bell-crater
Apulia, 'red-figure' technique, 4th century BC

The Judgement of Paris, as every schoolboy used to know, led directly to the Trojan War. Paris was asked to present a golden apple (the apple of Discord) to the fairest among the goddesses Hera, Athena and Aphrodite. Hera offered him empire, Athena wisdom and Aphrodite lust. he chose the latter, bribed by Aphrodite's promise of Helen. Here we see Hermes apparently putting Hera, Athena and Aphrodite through their lines before Paris's arrival on the scene.

AN 1944.15. H: 37 cm

Lit.: *Enciclopedia dell' arte antica* 6 (1965) 693, fig. 802; A. D. Trendall and A. Cambitoglou, *The Red-figured Vases of Apulia* 1 (Oxford, 1978) (attributed to 'the Rehearsal Painter'); *GV* No. 68

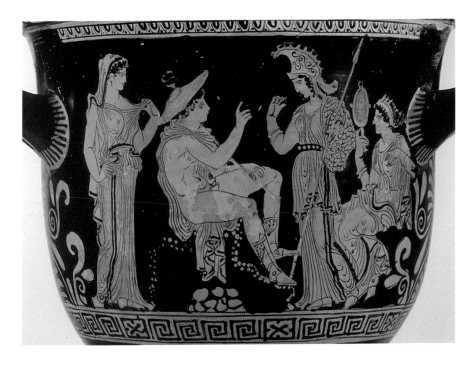

52 Volute-crater
Apulia, 'red-figure' technique, 4th century BC

The scene on the front is apparently funerary. A woman, presumably the deceased, sits in a *naiskos* (a 'small temple' – the regular surround of the more elaborate variety of gravestone). She holds a fan and a wreath. On either side stand a youth holding an *oinochoe* and a long-handled *patera* (a libation vessel), and a woman with a patera and a chain of flowers. On the neck is a head of a woman between floral scrolls of a kind that were extremely popular in the decorative arts of the later fourth century BC, and which have been associated with the painter Pausias. There is a similar scene on the back.

AN 1947.265. Formerly Cook collection.
H: 55.5 cm

Lit.: A.D. Trendall and A. Cambitoglou, *The Red-figured Vases of Apulia* 2 (Oxford, 1982) 727, pl. 268.4 (attributed to 'the Patera Painter'); *GV* No. 69

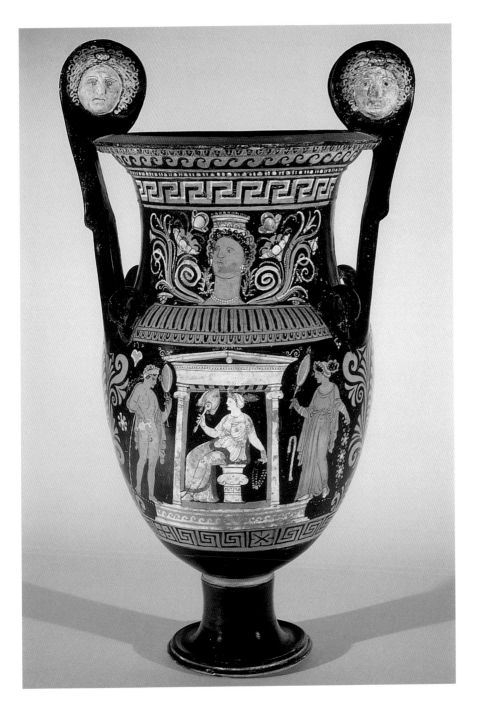

71

53 Rhyton in the form of a Laconian hound
Apulia, 4th century BC

Drinking cups made in the form of animals' head are not uncommon either in fifth-century Athens or southern Italy in the fourth century. Even some silver and gold examples survive. Horses, cows, mules, deer, goats rams, boars, dogs, lions, griffins, *ketoi* (sea-monsters), were all modelled by the makers of Tarentine rhyta. The face of the animal is often glazed and the neck painted with figure decoration, but here the surface is plain. A Laconian hound was drawn in the tondo of No. 26; this creature is almost as elegant.

AN 1885.644 (V. 337). Formerly Castellani collection. L: 20 cm

Lit.: H. Hoffmann, *Tarentine Rhyta* (Mainz, 1966) 47, pl. 56.1, No. 270; *GV* No. 70

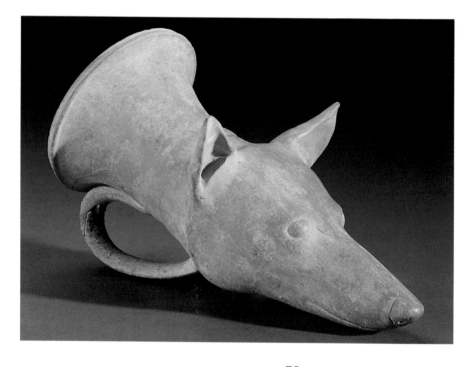

54 Fish plate
Apulia, 'red-figure' technique, 4th century BC

Plates decorated with fishes are common in both Apulia and Campania, and were almost certainly used for serving sea-food. They are regularly decorated with three or more fish around a central depression which presumably served to catch the liquid which drained from the cooked fish. Cuttlefish, red mullet, rock fish and rays as well as shrimps and shell-fish regularly occur. Here we have a torpedo (an electric ray) and perhaps two sea-bream: both expensive fish in antiquity. A silver fish plate has been found in Macedonia.

AN 1880.23 (V. 447).
Found at Cumae, near
Naples. Formerly
G. J. Chester collection.
D: 20.5 cm

Lit.: E. F. Bloedow and
C. Björk, 'An Apulian
red-figure fish plate', in
P. Brind'amour, (ed.),
*Mélanges offerts en
hommage au Révérend
Père Etienne Gareau*
(Ottawa, 1982) 123,
pl. 19

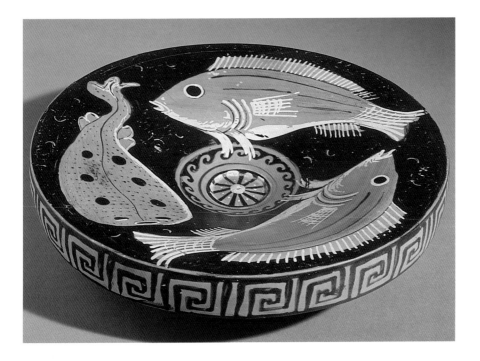

55 Skyphos
Paestum, 'red-figure' technique, 4th century BC

An actor wearing *phlyax* costume: a padded tunic and trousers with added genitalia, bends down to work the strings which serve to turn the revolving wheel upon which a female acrobat is balancing on her hands. The scene recalls the floorshow in Xenophon's *Symposium*.

AN 1945.43. Formerly MacDonnell collection. H: 14 cm

Lit.: A.D. Trendall, *Papers of the British School at Rome* 20 (1952) 34, pl. 56 (attributed to 'the Asteas Group'); *GV* No. 73

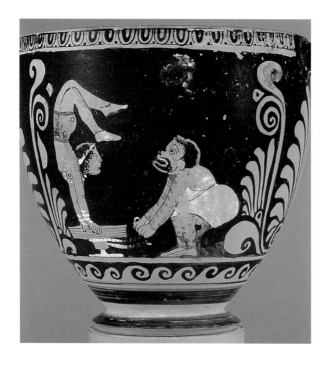

56 Lekythos
Campania, 'black-figure' technique,
4th century BC

A 'black-figure' tradition survived after a fashion in Campania until the end of the fourth century (an indication, presumably, of the presence of 'silver-figure' decoration on bronze vessels). The usual Campanian shape is a lekythos like this one, and the decoration a bird, a seated woman or a head. Few are as interesting as this head of an aged satyr.

AN 1891.322. Found at Vico Equense, near Naples. H: 16.5 cm

Lit.: *GV* No.74. The type is discussed by P. Mingazzini, *CVA* Capua III (1958) IV E s, pl. 10

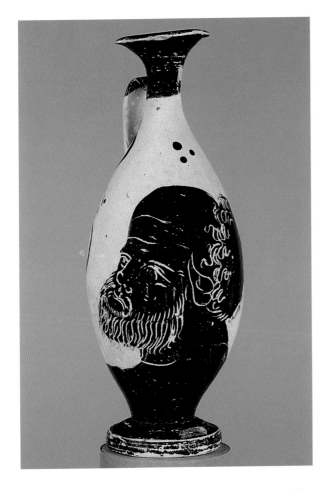

57 Hydria
Egypt, 'Hadra' ware, 3rd century BC

'Hadra' vases are so-called because many were found in the Hadra cemetery near Alexandria. Their shape has much in common with that of fourth-century Athenian Panathenaic amphoras (silver examples of which are recorded in 3rd century BC Alexandria), and they are notable in that the floor of the pot is well down inside the foot. Many are inscribed in Greek on the belly and beneath the foot as here. This Hadra hydria contains the ashes of a certain Nikostratos, a Chian envoy, who may have died in March 209 BC while preparing for the joint embassy of Rhodes, Chios and Egypt to Philip V of Macedon, which took place in the summer.

AN 1920.250. Found in Egypt. Gift of J. G. Milne. H: 43 cm

Lit.: T. Rönne and P. M. Fraser, 'A Hadra-vase in the Ashmolean Museum', *Journal of Egyptian Archaeology* 39 (1953) 89–94, pl. 5; GV No. 75

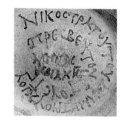

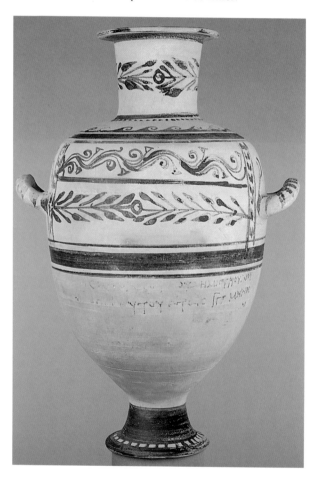

58 Pyxis
Athens, 'West Slope' ware, 3rd–2nd century BC

The vessel has a slipover lid which covers the whole wall of the body and rests on a projecting keel below. It is supported on three feet shaped like lions' claws below and sirens (birds with women's heads and breasts) with outstretched wings above. The convex lid is decorated on top with a moulded relief of a Dionysiac group; most of the decoration, however, is incised into the brown surface of the pot; incision that is characteristic of the so-called 'West Slope' ware that was made at Athens and elsewhere throughout the Eastern Mediterranean from about the end of the fourth century to the end of the first century BC, much of it based on silverware.

AN 1976.71. Found in Thessaloniki, Greece. Formerly Bomford collection. H: 16 cm

Lit.: *Anzeiger* 1981, 549–550; *Report* 1975–6, pl. 2; *GV* No. 76; Z. Kotitsa, *Hellenistische Tonpyxiden* (Mainz, 1996) 114, 137, 198, pl. 38, figs 97, 135–6

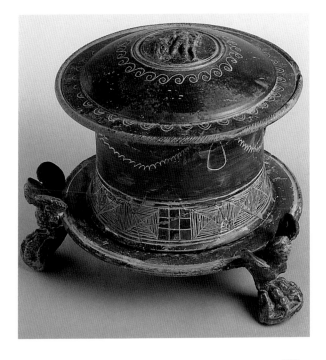

59 Trade amphora, 2nd century BC
Rhodes, 2nd century BC

Most of the pottery vessels described in this booklet were decorative rather than simply practical objects. Trade amphoras, by contrast, were made in order to carry goods over long distances. They might contain wine, oil, or garum (a kind of fish sauce widely used in antiquity) – or even dry commodities. Their shape made them easy to carry by hand, or on a pack animal (see photo), or to stow in the hold of a ship. This amphora was made in the island of Rhodes, and the unfired pot was stamped with the name of the magistrate Xenophon, son of Agrianios, who flourished *c.* 175–150 BC.

AN 1956.932. Found at Tharros, Sardinia

Lit.: 'Recent acquisitions by the Ashmolean Museum, Oxford', *Archaeological Reports for 1960–61* 58, No. 25

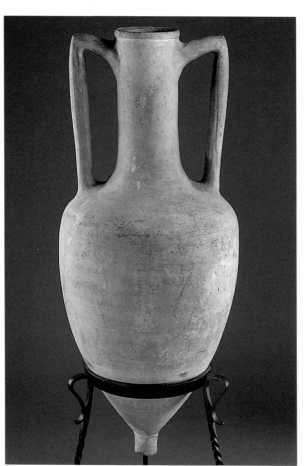

AN 1984.41: South Italian pottery baby feeder, 4th century BC

Lit.: M. Vickers, 'Recent acquisitions of Greek and Etruscan antiquities by the Ashmolean Museum, Oxford 1981–90', *Journal of Hellenic Studies* 112 (1992) 247, pl. 8a

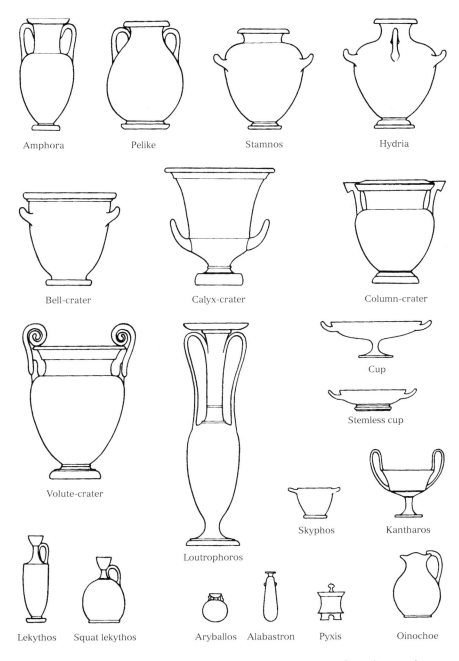

Amphora

Pelike

Stamnos

Hydria

Bell-crater

Calyx-crater

Column-crater

Volute-crater

Cup

Stemless cup

Loutrophoros

Skyphos

Kantharos

Lekythos Squat lekythos

Aryballos Alabastron Pyxis Oinochoe

Some shapes and
names of Athenian pots

Abbreviations

ABV J.D. Beazley, *Attic Black-figure Vase-painters* (Oxford, 1956)

Anzeiger 1981 M. Vickers, 'Recent acquisitions of Greek antiquities by the Ashmolean Museum', *Archäologischer Anzeiger* 1981, 541–561

Artful Crafts M. Vickers and D.W.J. Gill, *Artful Crafts: Ancient Greek Silverware and Pottery* (Oxford, 1994, 1996)

ARV² J.D. Beazley, *Attic Red-figure Vase-painters*, second edition (Oxford, 1963)

Beazley Gifts Ashmolean Museum, *Select Exhibition of Sir John and Lady Beazley's Gifts to the Ashmolean Museum 1912–1966* (Oxford, 1967)

Bomford Collection Ashmolean Museum, *Antiquities from the Bomford Collection* (Oxford, 1966)

Burlington 1975 M. Vickers, 'Recent museum acquisitions, Greek antiquities in Oxford', *Burlington Magazine* 117 (1975) 381–391, figs. 67–94

CVA *Corpus Vasorum Antiquorum* 1 (Oxford, 1927), 2 (Oxford, 1931), 3 (Oxford, 1975)

GV M. Vickers, *Greek Vases* (Oxford, 1978, 1982, 1988)

Report *Ashmolean Museum Annual Report of the Visitors*

Spencer-Churchill Ashmolean Museum, *Exhibition of Antiquities and Coins purchased from the Collection of the late Captain E.G. Spencer-Churchill* (Oxford, 1965)

V P. Gardner, *Catalogue of the Greek Vases in the Ashmolean Museum* (Oxford, 1983)

Further reading

H. **Hoffmann** *Sotades: Symbols of Immortality on Greek Vases* (Oxford, 1997)

F. **Lissarague** *The Aesthetics of the Greek Banquet: Images of Wine and Ritual* (Princeton, 1990)

R. **Osborne** *Greek Art* (Oxford, 1998)

P.J. **Russell** (ed.) *Ceramics and Society: Making and Marketing Ancient Greek Pottery* (Tampa, 1994)

B.A. **Sparkes** *Greek Pottery, an Introduction* (Manchester, 1991)
———— *The Red and the Black: Studies in Greek Pottery* (London, 1996)

M. **Vickers, O. Impey and J. Allan** *From Silver to Ceramic: the Potter's Debt to Metalwork in the Greco-Roman, Chinese and Islamic Worlds* (Oxford, 1986)

M. **Vickers and D.W.J. Gill** *Artful Crafts: Ancient Greek Silverware and Pottery* (Oxford, 1994, 1996)